The Science & Art of
Commercial *Acting*

by John Howard Swain

TABLE OF CONTENTS

The Buzz from some of
the Top Agents in the Country

"I know when I see John Swain's name on an actor's resume, that actor is serious about his craft and will be prepared. This is high-caliber training."

"From beginning actors just starting out to professionals looking to sharpen their skills, John Swain is the go-to guy."

"A no-nonsense, no empty-flattery classroom environment where actors really learn their craft."

"We regard the actors coming out of John's classes as some of the best trained actors in the Bay Area."

"I recently sat in on a class at John's school and wanted to sign everyone in the class."

"John's school not only has great classes taught by great teachers, it is also a great asset to the acting community."

"John's students tower above the rest."

"John Howard Swain runs a school (Full Circle) that most accurately prepares the actor for the realities of the professional film world. The classes there are a must for anyone who wants to work in the business."

"'You're booked'...are words our clients who study with John hear on a regular basis."

SHOUT OUTS

This book would be impossible without the help of a great number of people. First, to all of the students who studied at Full Circle Productions in San Francisco, where this technique was developed, and to those who are currently studying with me in New York City. Teaching, especially teaching acting, is a two-way street and I easily learned as much from you as you learned from me.

To the teachers and the staff at Full Circle and to my crew in New York—Celia Shuman, Joie Seldon, Barbara Scott, John X. Heart, Billie Shepherd, Janice Erlendson, Mary Moore, Katherine Lee, David Skelly, Tom Kelly, Mary Mackey, Lee Kopp, Elizabeth Ross, TJ Metz, Jennifer Skelly, Kristie Cox, Ginger Nicolay-Davis, Soraya Knight, Jessica Rauum, and Sarah Ann Rodgers—for all your hard work and dedication.

To Stacey Scotte, Elizabeth Pickett, and Don Schwartz who proofed and added their editorial expertise to this material. To Joe Sheehan (that's him on the cover) and Janet Petros for taking those photographs of Joe. To Bill Brooks for his excellent design work—both on the cover and on the inside of the book as well.

And last, but by no means least, to Marsha Mercant who not only enriched the lives of many of our students but who has been the bright light in my life for many years.

The proof of any kind of instruction is: did it work? The actors who studied these techniques have booked well over 6,500 jobs. These numbers beg the question: do these techniques work or have we just been blessed with exceptional students? The truth lies somewhere in between. We offered something unique and our students worked hard to apply what they learned.

Many of our students continue to make their living working in film, television, and theatre all over the world. Several have gone on to become directors, producers, and writers; all of them cite their time with us as the seminal event in their learning process. It was certainly an exciting, exhilarating, life-altering experience for me. I thank you one and all.

John Howard Swain

Introduction

Don't Skip This

Actors have a love/hate relationship with commercials. They want to do them because the money is good, but most actors don't understand the complexities of the form. Commercial acting requires a set of very specific skills.

Commercials can and often do play an important role in an actor's career. A commercial could be an actor's entrée into the union; residuals can pay the rent or help an actor qualify for health insurance.

Actors of every type and stripe have performed in commercials: journeymen actors as well as some of our biggest stars. Dustin Hoffman, Jodie Foster, and Hilary Swank made commercials long before winning their Academy Awards. Robert Duvall performed in commercials both before and after winning his Oscar for Best Actor.

The majority of actors tend to approach commercial auditions as if they were shooting craps, never realizing there is a technique they could use that could turn the process into a series of simple acting exercises. What most actors lack isn't talent but technique.

A basketball player (excuse the sports metaphor; I've been a jock all my life) will spend countless hours running drills: passing, dribbling, rebounding. When he is done with those drills he'll execute plays, both on the offense and the defense, all designed to enhance his court knowledge. After running plays he'll spend even more hours perfecting his shooting: free throws, lay-ups, hook shots, jump shots, dunks, field goals, three pointers. He does this hour after hour, day after day, turning what were initially ungainly, awkward movements into elegant, fluid actions.

When game time comes he knows what to do and how to do it; it's ingrained in his consciousness. He no longer has to think about how to pass the ball or where he should be in a zone defense or when to shoot, because the technique he's been practicing, the science of how to do a thing, has transformed itself into art.

Before the other team inbounds the ball he knows whether he's playing zone or man-to-man defense. When one of his teammates rebounds an opponent's shot he knows to take off downcourt to set up the fast break. If he's covered he knows which of his teammates is charging down behind him and how to get the ball to him.

Technique is the vehicle that transforms science into art. The difference between actors and basketball players is that actors know far in advance where, metaphorically, and how each ball is going to bounce. This doesn't mean they can slack off and do less. Just the opposite— they need to do more. The tools of an actor's trade are not balls and hoops; actors earn their living telling stories (yes, even in commercials), and if those stories aren't carefully mapped out and executed there's no way the actors will book the job.

There are many similarities between a commercial audition and a film and/or stage audition. There are also some glaring differences. The first difference is the basic premise of commercials. Ninety-five percent of all commercials are problem/solution scenarios. Someone has a problem, you have the solution and you're going to help the other person solve his problem. This flies in the face of almost everything an actor has been trained to do.

In "regular" acting classes actors are trained to fight to get what they want, not help the other person get want he/she wants. Actors are taught, and rightly so, that fighting for what they want builds tension and increases conflict, and those elements make for better storytelling. This is true.

Commercials are all about solving problems, not creating them.

What's also true is that this isn't how commercials work. Commercials are all about solving problems, not creating them. Madison Avenue figured out a long time ago that the best way to sell a product is to help rather than to hinder.

This is true whether it's one character talking directly to the camera or a group of characters that talk amongst themselves and never actually address the camera. With the former, the information divulged is direct; with the latter, the information divulged is implied. Either way, the commercial is a problem/solution scenario designed to sell a product.

You can't solve the problem if you don't know what it is. Because the majority of commercials are problem/solution scenarios, the first

thing you need to do when you're handed a piece of commercial copy is to figure out what the problem is. Is someone having car trouble? Money issues? Do they have a headache? Are they trying to quit smoking? Get a stain out of a blouse?

I encourage you to test this premise. Once you discover its validity you will have a piece of the puzzle most actors never see.

Another thing that differentiates a commercial audition from a film audition is that commercial actors are, for the most part, restricted to one emotion—joy. That doesn't mean you won't bump up against sadness or anger or jealousy or some of the other negative emotions, but you're only going to lightly brush up against those emotions as you travel through commercial land.

Again, the reason for this is because the ad agencies know that the best way to promote a product is to put a positive spin on it. Every now and then a negative ad campaign will pop up, but, by and large, commercials send a positive message.

Joy is the default emotion for commercials. This overt positivity trips up a lot of actors. Actors aren't used to working this way. They're used to being in situations rife with stress and controversy. They're trained

> *Joy is the default emotion for commercials.*

to do battle, in both comedy and drama, in order to get what they want. They know that conflict and tension enhance a story and resolution and harmony flatten it.

This isn't to say there won't be negativity in commercials, but that negativity is going to be resolved quickly rather than amplified and drawn out.

Actors (and writers) are adept at manipulating negative and positive situations and they'll often use a negative to set up a positive. The writer will write, "I hate you," so that when the actor finally says, "I love you," it has more impact. Because there is no real, sustainable anger in commercials, actors can't depend on this device. They'll also have to learn how to set up a positive situation with another positive. This can be tricky if you're not used to doing it; tricky, but not impossible.

In order to be successful in commercials you have to switch your approach and come at the craft from a different perspective. Instead of trying to create conflict you have to promote resolution. In a dramatic scene (or a comic one) you would normally fight for your point of view.

In a commercial you have to surrender your need to be right and be willing to help the other person overcome his problem.

Language is the next hurdle. The dialogue for film and stage is written to sound as realistic as possible. Screenwriters write to create a mood. They know a false line can jar the audience and break their concentration. This isn't necessarily the case with commercials.

Commercial copy is written to sell a product. That doesn't mean the writing is bad, but it is different. Think about it: nobody in real life talks the way a character talks in a commercial. When was the last time you had a conversation with someone about the lettuce, onion and pickle on your hamburger? Yeah, I never had one either.

In order to be successful in the commercial world you have to master "commercialspeak."

In order to be successful in the commercial world you have to master "commercialspeak." Commercials are, for the most part, written in code. Part of your job is to learn the code and be able to translate it.

If you want to make it past the first audition you'll need to:

- *Figure out the problem.*
- *Learn how to use joy as your main emotion.*
- *Become fluent in commercialspeak.*

The Slate

The slate is the first thing that happens at the audition. It's also the most important part of the audition. Yet very few actors know how to do it properly. When you walk into a studio the casting director points the camera at you and asks you to slate your name. It sounds simple; we all know our names. But do you know how to say your name so that the people watching the playback of your audition will lean forward in their chairs and be excited to hear what you have to say next?

The people watching the playbacks have the power of the remote. If your slate grabs their attention they'll watch the rest of your audition. If it doesn't, they'll fast-forward to the next person.

Look at it from their point of view. Let's say an ad agency is casting a national detergent commercial. They're looking for a "young mom" between the ages of twenty-eight and thirty-five. The ad agency hires a casting director and the casting director is going to audition you, plus a hundred and forty-nine other actors, and send those auditions to the ad agency. The agency people are going to watch everything the first ten actors do. Eight of those actors won't be properly prepared; they're either having a bad day or they haven't done their homework.

After the twentieth person, and the fifteenth or sixteenth not-so-good audition, the ad agency people are starting to get upset. "What's wrong with these actors?" is one of the more polite questions being asked during the playback session. Other things, not quite so polite, are also being said. So they watch, their fingers poised on the remote, looking for any reason to fast-forward.

Your slate is your passport to the next part of the process.

You're the eighty-fourth person to audition. By this point the ad agency people have already seen seventy-plus subpar auditions. The remote is pointed at the DVD player and the instant an actor makes a mistake they hit the fast forward button and move on to the next person. Any excuse will do.

To understand this let's back up a step. The people at the ad agency have a problem. They need to find somebody to help them sell their product. They watch the playbacks with great expectations. This commercial is huge for them and for their careers. If it goes well they'll get to keep their jobs (or get promoted); they'll be able to make their mortgage payments, keep their kids in private school, buy a boat; whatever.

They want the actors to do well. They're rooting for every actor who auditions. But because so many actors aren't properly prepared, the ad agency people are in a constant state of frustration. They see their hopes for the project crumbling around them as actor after actor fails to meet their expectations. You'd be frustrated too.

This is why your slate has to be really good. Your slate is your passport to the next part of the process. If your slate sends the message, "I know what I'm doing," then the ad agency people will watch the rest of your audition. If it doesn't, they'll move on to the next person.

So, what can you do to make sure your slate is working? Put someone you don't know in the camera and introduce yourself to that person. It's important that the person you put into the camera lens for the slate is someone you don't know. Later, for the actual audition, you'll be using someone you do know, but for the slate put someone in the camera you don't know and then introduce yourself to that person.

> **Whom you pick to slate to is important.**

Whom you pick to slate to is important. Commercials aren't written to be too "meaningful" or "heavy-handed;" they are written to sell products. So, although the person you'd most like to meet more than anyone else in the whole wide world might be the prime minister of Outer Uzbekistan, he may not be the best person to slate to at a commercial audition. Pick someone you think would be fun to meet: Will Smith, Anne Hathaway, Drew Barrymore; someone like that.

By choosing someone you don't know, someone who seems as if they would be fun to hang out with, and by putting that person in the camera and then introducing yourself to him/her, you've created a sense of anticipated excitement that is the stock and trade of commercials. If you do this, the ad agency people who are watching the playback of your audition (and ultimately the customers watching the commercial) will see you and think, "Hey, he seems like a nice person. I'd like to hear what he has to say." You've made it personal, you've made a connection and you've created a sense of aliveness that most actors won't bring to the slate.

If you work in film or on stage you'll need to make an adjustment when you're auditioning for commercials. And vice versa. There is a lightness, an eagerness, to a commercial audition that doesn't work with other auditions. In commercials, resolution is king and if you don't bring a quality of lightness and eagerness to your audition, you won't book. This is not about being all smiley faced but about generating the feeling you get when you help a friend solve a problem.

PROFILES

Sometimes, after you've slated, you'll be asked for your profiles. This is another place where actors can stumble. They'll start off well, they'll put someone in the camera, but when they turn to show their profiles, all the energy that went into the initial introduction drains away. It's important to maintain that energy.

When you turn to show your profiles, put the person you slated to in the camera to your left and see them there. Same when you turn to the right. Don't make a big deal out of it; just see them when you turn to either side and maintain the same vitality that you had when you first saw them in the camera. Just by seeing that person and by thinking how cool it is to meet them will help you maintain your energy.

> *The time you spend in profile should be short: one to two seconds.*

The time you spend in profile should be short: one to two seconds. Your focus should always stay at eye level. But don't automatically turn to show your profiles unless the casting director asks for them—not every casting director will. Also, ladies, if you have long hair, please make sure it is pulled back so we can see the side(s) of your face.

One last thing about slating: take all the hero worship out of the slate. Will Smith wants to meet you just as much as you want to meet him. Same with Anne Hathaway. Same with whomever you choose to put in the camera for your slate. It's like you're at a party, you turn around and there that person is. All you have to do is say, "Hi, I'm John Smith" or "I'm Jill Jones."

Each step of the audition is important, but slating properly, getting the attention of the people watching the playback, is the most crucial.

Exercise

Pick four different people you would like to meet. Fun people, people whom you think it would be great to hang out with.

Practice putting them in the camera (don't see them full length, just head and shoulders) and introduce yourself. If you don't have a camera draw a small circle on the wall at eye level and practice putting them in there. Use your imagination; pretend you see them and say, "Hi, I'm _____."

From Slate to Copy

F or the slate you want to put someone in the camera *you don't know but would like to meet,* but for the actual copy you want to put someone in the camera *you do know and want to help.*

Creating this relationship with the person you want to help is vital to your success and it's important for you to know "whom" you're talking to.

Let's look at single-person copy to start with. Single-person copy is just what it says: it's one person (you) talking directly to the camera. This scares the crap out of most actors. It's like doing a one-man show; it's all you and there's no place to hide. But it doesn't have to be daunting.

Once you've identified the problem, ask yourself who from your real life, past or present, has or has had a similar problem. My friend Tommy is always having money issues, so if I'm doing a commercial for loans or banks or credit cards, I'll use him. Richard is always having car issues, so if the spot concerns car repair or buying a car, new or used, I'll put him in the camera and talk to him.

By putting someone you know in the camera, someone who has a problem similar to the problem mentioned in the copy, you've made your job immeasurably easier. If you don't put someone in the camera to talk to you'll end up trying to talk to a one-eyed, three-legged monster.

> *If you don't put someone in the camera to talk to you'll end up trying to talk to a one-eyed, three-legged monster.*

A couple of guidelines about whom to put in the camera: pick someone you like, someone who will be receptive to your advice. Do not, if possible, use your best friend or a close relative. We shorthand the way we speak to those people and while they may know what we're saying, other people, the people viewing the playback of your work, may not. Clarity isn't only desired, it's essential.

Picking the right person to talk to is extremely important. A good way to determine if you've picked the right person is to ask yourself this question: will this information, the solution to this problem, change that person's life? If not, you've picked the wrong person and should try someone else.

Don't forget, commercials, like films or plays, deal with heightened moments of reality. Someone has a problem and your job is to help solve that problem. The copy may be trite (e.g., advising your neighbor about what lawn products to use may sound trivial), but you need to keep the stakes as high as possible. If you don't think what you're saying is important, it will seem as if you don't care. If it appears you don't care, the clients won't hire you to represent their product. And from an acting standpoint, if you don't maximize the stakes in every situation, you end up playing indifference, and indifference is not only difficult to play, it's also boring as hell to watch.

> If you don't think what you're saying is important, it will seem as if you don't care.

This isn't a license for you to get heavy-handed or overly serious; just the opposite. Joy, in one of its thousand different manifestations, is the constant emotion you'll use as you navigate your way through commercial land. The people watching the playback need to know you care. They need to know you're serious about solving the other person's problem, but at the same time they need to know you're delivering the solution from a place of joy.

This doesn't mean you smile your way through the commercial. The smile, if there is one, is a result of the joy that comes from helping your friend. The smile is internal. If it manifests itself into an external expression, an actual smile, that's great, but you have to work from the inside out. You can't simply plaster a grin on your face, say the words and expect to book the job.

Why is this person asking you for help? The reason the person you put in the camera has asked for your advice is because they know that you've either had the same problem in the past and you've solved it or that you're a spokesperson for the company.

Sometimes you're going to have to stretch your imagination to give the problem the oomph it needs to be important, to make it playable. If your roommate needs to know which brownie mix to use, you'll need to create an appropriate scenario in order to give the copy some real substance. The reason she is seeking your advice is because she's trying

to impress a new guy she's dating. If the brownies are great, he'll ask her out again and soon her romance will be in full bloom. Melodramatic? Yes. But now, advising her on which brownie mix to use has taken on a level of importance it didn't have before, and that level of importance has made the situation easier to play and more interesting to watch.

> Sometimes you're going to have to stretch your imagination to give the problem the oomph it needs to be important...

Once you've determined what the problem is, and you've figured out whom from your real life you're going to put in the camera to talk to, and you've raised the stakes so that solving that problem takes on an amplified sense of importance, then you'll be well on your way to hearing those words we all love to hear: "You're booked."

EXERCISE

Practice switching from the person you're slating to (someone you don't know but think it would be fun to meet) to a friend (someone you do know and want to help).

To do this you'll need a couple of pieces of copy. There are samples in the back of this book.

If you want more copy, record a couple of hours of prime time television and use the commercials from those shows. Caution: using radio copy isn't a good idea. Radio copy isn't supported with pictures the way television copy is. It makes a difference.

Read the copy. Determine what the problem is and then figure out who is the best person you know to put in the camera.

After you've done that, practice slating to the camera (or the circle on your wall) and then, before you say the first line of the copy, switch to your friend. Have one face replace the other.

This takes a little practice but it is doable and very important.

CHAPTER THREE

Relationships

There are six key elements to breaking down a commercial. The first, and perhaps the most difficult, is to *identify* and *play* all the relationships in a piece of copy. Relationships are the key to all good acting. It's important to understand that when you go on an audition your job isn't to show the casting director how good an actor you are. It isn't?! No. Your job is to show him/her how good you are at creating relationships, and it is your ability to create relationships that tells them how good an actor you are. If you can turn a mop into a dance partner, you've got it made. If you can take an empty plate and convince the people watching your audition that it's really a dish of steaming, mouthwatering lasagna, you'll get the job. If you can make a stranger seem like your loving spouse, you'll work forever.

You've already created two of the most important relationships you will need to have a successful audition—the person you're slating to and the person whose problem you're going to solve. You also need to know who you are. Are you merely a friend to the person you're talking to or are you a spokesperson for the product? You could be both. Either way, you're a friendly authority on the subject—with an emphasis on friendly.

A little background information will help you project the proper status. Example: if you're a spokesperson for the product you should definitely include a little pride in the way you deliver the lines. Hint: if the words "we," "our" or "us" are part of your dialogue then you're a spokesperson.

In addition to knowing who you are you'll also need to have a relationship with the product—The Hero. You may also need to have a relationship with Brand X—the competitor's brand. You'll also need to create a relationship with the other people mentioned in the spot. If you talk about Aunt

> *... in addition to the product, you'll need to create a relationship with every person, situation or event that is mentioned in the script.*

Agnes we, the viewers, need to know how you feel about her. If there is an event (an anniversary) or situation (a baseball game) mentioned in the spot you'll need to create a relationship with those as well. In other words, in addition to the product, you'll need to create a relationship with every person, situation or event that is mentioned in the script.

Then, once you have identified all those relationships, you'll need to assign a positive or negative value to each. Example:

DUNCAN HINES

(TALENT SITS WITH A SMALL GROUP OF PEOPLE AT A PICNIC TABLE IN A BACKYARD. HE HOLDS A PLATE WITH A LARGE SLICE OF CHOCOLATE CAKE ON IT. BEHIND HIM WE SEE A BIRTHDAY PARTY IN FULL SWING: GUESTS TALKING, KIDS PLAYING GAMES, BALLOONS, STREAMERS, ETC. SEVERAL GROUPS OF PARTYGOERS SIT OR STAND IN VARIOUS CLUMPS AROUND THE BACKYARD, SOCIALIZING.)

TALENT (turning to camera): **IT WAS MY BIRTHDAY PARTY AND MY AUNT JEAN MADE HER FAMOUS DUNCAN HINES CHOCOLATE CAKE.**

UNFORTUNATELY, MY COUSIN JOEY WAS INVITED TO THE PARTY TOO.

BUT EVEN JOEY CAN'T RUIN A GREAT CAKE.

(TALENT, using a fork, cuts a bite of the cake and eats it.)

When it comes to identifying the relationships, here's what we've got: IT WAS MY BIRTHDAY PARTY (*positive*) AND MY AUNT JEAN (*positive*—we're assuming you like her) MADE HER FAMOUS DUNCAN HINES CHOCOLATE CAKE (*positive*—this is The Hero product). UNFORTUNATELY, MY COUSIN JOEY (*negative*—the word "unfortunately" tells you all you need to know about how you should feel about Joey) WAS INVITED TO THE PARTY TOO. BUT EVEN JOEY (*negative*) CAN'T RUIN A GREAT CAKE (*positive*).

So, in addition to the person you're slating to and the person whose problem you're trying to solve, there are six other relationships in the spot and the viewers need to know how you feel about each one. (Please note that Joey and the cake are counted twice because they're mentioned twice.)

Once you've identified the relationships and assigned a positive or negative value to each one, then you have to "adjust the volume" to reflect those feelings. How you feel about the birthday party is positive, but maybe not as positive as how you feel about the cake—the cake is The Hero, after all. Same for Joey: you mention him twice, but perhaps the second time his name comes up you don't feel quite as negative as you did the first time.

Please understand that the problem in this commercial isn't the fact that Joey showed up at your party. The problem is you have a friend who needs to know what's the best cake to serve at a party she's giving and you tell her about the cake that was served at your birthday party, the idea being that her knowing about your cake will solve her problem.

Earlier I said that in commercials you should keep everything positive, and that, for the most part, is true. The word "negative" is used here simply to add a different color. Joey isn't a child molester; he's just an obnoxious relative.

Finding the various relationships in a piece of commercial copy and then figuring out how you feel about each one is not easy. However, once you master this part of the technique, your chances of booking the spot have increased a thousand percent. Really!

When auditioning for a commercial, make sure your product relationship choices (except for Brand X) are positive. Remember, you're not acting in an intense drama like *Dog Day Afternoon*; you're simply trying to help a friend decide what to serve at a party.

> *When auditioning for a commercial, make sure your product relationship choices (except for Brand X) are positive.*

If you have any confusion about finding and evaluating the relationships in a piece of commercial copy please re-read the last six paragraphs. This is the hardest part of this technique and the most important.

SUBSTITUTIONS

In making good relationship choices you may need to do some substituting. If you don't love the product you're auditioning for, you need to think of something you do love and be thinking about that while you're talking about The Hero or the attributes of The Hero. Never forget, the camera can "see" what you're feeling by what you're thinking. For instance, if you're thinking, "I don't like chocolate," when you're auditioning for Duncan Hines Chocolate Cake mix, the camera will pick that up and the people watching the playback will sense that you don't like chocolate, and because they're trying to sell chocolate cake, you won't book the job.

So, if ZZZ Detergent doesn't make your heart sing, think about something that does, and make sure you're thinking about that while you're extolling the virtues of ZZZ Detergent.

If you don't make a substitution, you'll be sending the wrong information. There is way too much money involved for you not to make this simple adjustment. An ad agency is going spend anywhere from two to ten million dollars on a national commercial. If anyone involved in the hiring process has even the remotest inkling that you don't love the product, you aren't going to get hired.

Would you entrust ten million dollars of your advertising budget to an actor who wasn't totally onboard with your product? Neither would I!

> *The substitutions you make are merely done to generate the feelings you want to project.*

The substitutions you make are merely done to generate the feelings you want to project. If the product is frozen peas and you can't stand frozen peas but you love fish sticks, then think about fish sticks and how good they are each time you mention frozen peas. The viewers will "see" the love you have for what you are thinking about and they will automatically make the leap that what you are thinking and what you are saying are one and the same. It doesn't matter what you use as a substitute: rock 'n' roll, money, mom's homemade cookies, sex; just make sure that if you need to use a substitute you use something that you personally love.

THE HERO VS. BRAND X

Okay, I know I need to love The Hero but what do I do with Brand X? Today's television audience is much more sophisticated than it used to be. In today's climate there is no need to trash Brand X in order to celebrate the virtues of The Hero.

The best way to handle Brand X is to dismiss it lightly. This works especially well by elevating the status of The Hero (whether you actually love the real product or you're using a substitute).

The following is an example of how a commercial works when Brand X is used to help sell The Hero.

CREAM CRISPS

TALENT: **MOST COOKIES ARE ALIKE.**

BUT A CREAM CRISP IS SOMETHING SPECIAL.

LUSCIOUS CHOCOLATE MIXED WITH DELICIOUS VANILLA ON THE INSIDE;

CRISPY, CRUNCHY WAFER ON THE OUTSIDE.

CREAM CRISPS.

ONE BOX WON'T BE ENOUGH.

Here's how it looked when an actor broke it down in my class:

Problem: A friend is having guests over for tea and she wants to serve a small, tasty snack.

Solution: Cream Crisps.

Friend: June, my next door neighbor. Why is she seeking my advice? June knows I entertain all the time, for all sorts of occasions.

Substitution: Do I love Cream Crisps or do I need to substitute something else for this? I've never even heard of these cookies before so I'm going to substitute Rocky Road ice cream for The Hero.

TALENT: **MOST COOKIES ARE ALIKE.**

The cookie is Brand X. I don't want to trash it, but I don't want to do anything to elevate its status either. I want to be slightly dismissive.

BUT A CREAM CRISP IS SOMETHING SPECIAL.

This is The Hero product. I want to be positive. I want to make sure I have a warm-fuzzy-feeling thing happening so I use my substitute, Rocky Road.

LUSCIOUS CHOCOLATE MIXED WITH DELICIOUS VANILLA ON THE INSIDE; CRISP, CRUNCHY WAFER ON THE OUTSIDE.

These are the attributes of The Hero. I want to be positive so I use my substitute again.

CREAM CRISPS.

Again, this is The Hero. I want to stay positive; I need to love this—I'm thinking Rocky Road.

ONE BOX WON'T BE ENOUGH.

This is about The Hero. Still positive, still needing to love it—I'm thinking Rocky Road, a double scoop.

Because both The Hero product and Brand X are mentioned, the actor has to strike the proper chord for each in the commercial. By creating joy and warmth for The Hero product, and by mildly dismissing Brand X, the story favors The Hero product.

The goal is for the commercial to influence consumers so that the next time they're shopping for a cookie-like snack they'll buy Cream Crisps instead of something else.

EXERCISE

Get several pieces of copy and start breaking each one down, identifying the various kinds of relationships in each piece of copy. Once you've identified the different relationships, figure out if they are positive or negative. When you've done that, start playing with the "volume." Is one relationship more positive than another? If so, adjust the volume so that one positive sounds a little better than another.

Look for lists. If you have a list of three attributes practice making those attributes sound different from each other. A good way to do this is to assign a "good," "better" or "best" value to each. In the Cream Crisp spot, the third line—"LUSCIOUS CHOCOLATE MIXED WITH DELICIOUS VANILLA ON THE INSIDE; CRISPY, CRUNCHY WAFER ON THE OUTSIDE"—"luscious chocolate" is good, "delicious vanilla" is better, and "crispy, crunchy wafer" is best. This creates variety and variety sparks interest.

Also, see if you can find a line in the copy you're using where you have both a negative and a positive relationship, such as in the Duncan Hines spot—"BUT EVEN JOEY *(negative)* CAN'T RUIN A GREAT CAKE *(positive)*." Practice going from one to the other. This is hard but not impossible. The key is to slow down. Going too fast with commercial copy will kill your audition because you won't be able to give full weight and value to each relationship.

CHAPTER FOUR

The Moment Before

In a commercial, as in a film or a play, your character needs to be coming from someplace. His life can't begin with his first line of dialogue. If you don't find some way of engaging in the storytelling before the scripted copy starts, you'll always be at least a beat behind and you will never catch up.

The good news is you don't need to do the elaborate work for a commercial that you would do in preparing for a film scene, but you do need to do something. So, what do you do?

The best way to make sure you're engaged is to come up with a question that your first line of dialogue answers. Then have the person you put in the camera, the one who has the problem, ask you that question.

This is like the game show *Jeopardy*. You know the answer; the answer is your first line of scripted dialogue. What you have to do is come up with a question that the first line of dialogue answers. If your first line is, "Snappy Cereal Sugar Pops are my kids' favorite," then the question the person in the camera asks you could be, "What do your kids like to eat for breakfast?"

Think of this as priming a pump. Answering your friend's question not only prompts your first line but also provides you with the spark of life you'll need to be fully engaged.

Make sure the Moment Before is a question and not a statement. A question begs a response; a statement doesn't. And if your first line in the copy is a question, have the person in the camera ask you the same question. Example: if your first scripted line is, "What's it like, driving a hybrid?"

> **Make sure the Moment Before is a question and not a statement.**

then the Moment Before is, "What's it like, driving a hybrid?" and your answer, your first line—"What's it like, driving a hybrid?"—becomes a rhetorical question.

"Action" is not your cue to talk. Once you've decided what the question is in the Moment Before, make sure you hear the question before you start talking.

This slight delay after the casting director calls, "Action" helps create the reality of being in the moment. Creating that reality, hearing that question, could be the difference between you booking the job or you standing in the unemployment line. This isn't brain surgery but it is important.

EXERCISE

Take a few pieces of copy and start creating questions that the first line of scripted dialogue answers. Keep the questions short and simple.

Using the Duncan Hines copy in the previous chapter as an example, your first line is, "IT WAS MY BIRTHDAY PARTY AND MY AUNT JEAN MADE HER FAMOUS DUNCAN HINES CHOCOLATE CAKE." The question in the Moment Before could be, "When was the last time you had some really good cake?"

See what I mean about brain surgery?

Start with the slate and remember to switch people, going from the person you slated to, to the person who has the problem. That switch should happen as soon as you finish the slate. If the casting director asks for profiles, you should make this switch (from the person you're slating to, to the person whose problem you're going to solve) as you turn back toward the camera after your last profile.

Don't forget, when the casting director calls, "Action," that is not your cue to talk; that is your cue to hear the question you created for the Moment Before.

Line-to-Line Objectives

As actors we have very little choice as to the words our characters have to speak. However, we have a tremendous amount of choice as to what the meaning, the subtext, of those words will be. You can say, "I adore everything you do," and if you say it with great affection it comes across as a loving compliment, the objective of the line being to flatter the other person, to make him/her feel loved. Or you can say those same words with biting sarcasm and it comes across as disapproval, with the objective being to hurt, to damage the other person.

The Line-to-Line Objectives are the messages that you want to communicate with each line of scripted dialogue. There are no throwaway lines in commercials. Each line has value; each line means something. Even lines that are meant to sound as if they're being "tossed off" have significance.

> *The Line-to-Line Objectives are the messages that you want to communicate with each line of scripted dialogue.*

Actors in film, as a rule, have less dialogue than they do in plays. The director of a film uses pictures and shot selection to tell his story. A commercial director does the same thing, but with a commercial you only have thirty seconds (sixty seconds max) to deliver the story. Therefore, each line or fragment of a line has tremendous importance and needs to have its own objective.

The disadvantage of acting in a commercial is that you're trying to swim with one hand tied behind your back. Not only are you limited, for the most part, to a single emotion—joy—but you're also hampered by awkward, coded language. Line-to-Line Objectives (L2LOs) can help you translate an obtuse line of commercialspeak into a clear, precise message.

The following is a commercial as it was handed to an actor in my class:

DENTAL FLOSS

(TALENT HOLDS UP A PIECE OF DENTAL FLOSS)

TALENT: **THIS CAN SAVE YOU THOUSANDS OF DOLLARS ON YOUR DENTAL BILL.**

REALLY...THOUSANDS.

DENTAL FLOSS. WHO SAYS YOU DON'T HAVE THE WORLD ON A STRING.

Let's start breaking the spot down. The problem is poor dental hygiene and/or expensive dental bills. The solution is dental floss. The dental floss is The Hero product. Pick a friend who has or has had poor dental hygiene and/or a lot of expensive dental bills and put him in the camera. He's come to you because he knows you had a similar problem in the past and you fixed it (maybe not you personally but your character).

You have four lines to solve your friend's dilemma. Yes, four. The actor's third speech is really two different lines. In commercials please pay close attention to the punctuation. The writer knows he won't be around for the audition so his punctuation is his way of telling you, "This is how I hear it."

> *In commercials please pay close attention to the punctuation.*

A period at the end of a line means *pause, new thought* (on the next line). A comma means *pause, continued thought*. An ellipsis (three dots) means *pause, new or continued thought*. Of course, there are exceptions to every rule but the examples stated above apply ninety-eight percent of the time. Learning how to play the punctuation is immensely helpful.

The language in the Dental Floss spot, while not as stilted as in some commercials, is still commercialspeak. Have you ever had a conversation like this with anyone? Unless you're a dental hygienist, probably not.

What you need to do now is create an objective for each line; figure out what you want each line to mean and then come up with a L2LO to help you get each one of those points across, the result of which will help you solve your friend's problem.

Here's what the same piece of copy looked like after the actor did the L2LO work:

DENTAL FLOSS

(TALENT HOLDS UP A PIECE OF DENTAL FLOSS)

TALENT: *(L2LO – to enlighten)* **THIS CAN SAVE YOU THOUSANDS OF DOLLARS ON YOUR DENTAL BILL.**

(L2LO – to reiterate) **REALLY…THOUSANDS.**

(L2LO – to boast) **DENTAL FLOSS.** *(L2LO – to joke)* **WHO SAYS YOU DON'T HAVE THE WORLD ON A STRING.**

We don't use commercialspeak in our everyday lives, but part of your job as a commercial actor, a big part of your job, is to make the language of commercials sound real. It doesn't matter how stilted the copy may sound or how strange the phrasing may be, the words—whatever they are, in whatever order they're written—need to roll off your tongue with ease. You can't stumble over the language and expect to get hired.

> *…a big part of your job is to make the language of commercials sound real.*

For your L2LO choices you want to use action verbs that are simple to understand and easy to play. Here's a short list to get you started. There are many, many more.

to announce	to entice	to prod
to boast	to exclaim	to prompt
to brag	to guarantee	to provoke
to caution	to help	to question
to celebrate	to hook	to rebuke
to challenge	to inform	to remember
to connect	to inquire	to reprimand
to convince	to introduce	to save
to discover	to invite	to seduce
to draw in	to joke	to solve
to educate	to laugh	to sympathize
to emphasize	to mock	to tease
to energize	to praise	to tempt
to enlighten	to proclaim	to warn

Some of these objectives have what could be considered negative connotations. We use these objectives because they best describe the point we're trying to make. If the L2LO you pick appears to have a negative undertone, you need to give it a positive spin. For example, "to warn" becomes "to warn lovingly" or "to challenge" becomes "to challenge affectionately." This expands rather than restricts your vocabulary as you search for the exact right L2LO.

Some actors find this process difficult. They say, "I can't do two things at the same time. I can't be thinking one thing while I'm saying something else." And I say, "Are you kidding? We do this all the time. We're always manipulating the meaning behind our words in order to get what we want." This is no different. It's just that now you have to manipulate someone else's words in order to win the job.

EXERCISE

Using a piece of copy, go through the steps one at a time: figure out what the problem is, what the Moment Before is, whom from your real life you're talking to, and then assign each line a L2LO. Don't forget, partial lines need to have their own separate objectives.

When you've finished, rehearse the copy, keeping in mind what the subtext is for each of the scripted lines. That's what L2LOs provide: the subtext for each line. And slow down so you can layer in that subtext.

CHAPTER SIX

Banter

O nce you've figured out what the problem is, whom you're going to put in the camera to talk to, what your Moment Before is and what your L2LOs are, then you need to work on the banter.

Commercial scripts, like film scripts, only give you about thirty percent of the information you need to tell the story. The rest is up to you, and the banter is a huge part of it.

The banter is a word or a short phrase that the person you've put in the camera says to you before each of your scripted lines. It, like the Moment Before, is something you make up. The banter serves many purposes: it helps you engage in the storytelling, it forces you to slow down, it gives you the opportunity to shift from one L2LO to the next, and most important, it sets up each scripted line. Here's another piece of commercial copy before the actor did any of the prep work:

> *...the banter turn(s) the script from a monologue into a dialogue.*

CUPID PERFUME

TALENT: **IF YOU WANT HIM TO TREAT YOU SPECIAL, WEAR SOMETHING SPECIAL.**

CUPID PERFUME, THE FRAGRANCE IN A CLASS ALL BY ITSELF.

YOU'LL LOVE IT AND HE'LL LOVE YOU FOR IT.

Here's the same piece of copy after the actor did her homework. The Moment Before is the first line of banter; notice how it and the rest of the banter turn the script from a monologue into a dialogue.

Problem: A woman trying to get her boyfriend to pay attention to her.
Friend: Mary, who thinks her boyfriend takes her for granted.
Solution: Cupid Perfume—The Hero. Mary has come to me because she knows I used to have trouble getting my boyfriend to pay attention to me.

CUPID PERFUME

Moment Before:
[MARY: WHAT CAN I DO TO GET BOB TO TREAT ME SPECIAL?]
TALENT: *(L2LO – to suggest)* **IF YOU WANT HIM TO TREAT YOU SPECIAL, WEAR SOMETHING SPECIAL.**

[MARY: LIKE WHAT?]
(L2LO – to boast) **CUPID PERFUME, THE FRAGRANCE IN A CLASS ALL BY ITSELF.**

[MARY: WILL IT WORK?]
(L2LO – to guarantee) **YOU'LL LOVE IT AND HE'LL LOVE YOU FOR IT.**

Now, instead of just some random lines, you have a scene. The scene is written in comercialspeak, but it is a scene. Of course, when you're auditioning, only the real dialogue will be spoken out loud, but the banter, the dialogue you made up, will have a significant impact on your work. It will engage you in the storytelling and help you set up each one of your scripted lines.

EXERCISE

Take a piece of single copy and create a question for the Moment Before. Then add the banter: a word or a short phrase your friend says to you before each scripted line. Do yourself a favor, keep the banter short.

Remember, you want each line of banter to set up the next line of real dialogue. Look at Mary's second line of banter in the above example—"LIKE WHAT?" That is a perfect set up for "CUPID PERFUME, THE FRAGRANCE IN A CLASS ALL BY ITSELF."

CHAPTER SEVEN

The Tag

As each commercial needs a beginning, the Moment Before, it also needs an ending, a "tag." About half of the time the tag (AKA "the button") is written into the copy, either in the dialogue or by an action indicated in the script. But if it isn't, the actor needs to create it.

All too often actors rely on the person running the camera to finish their auditions for them. Don't. They're busy, making notes, jotting down footage numbers, eating lunch, or any of a thousand other things.

If a tag isn't written into the copy then your job is to come up with one. How do you do that? The last thing you want to do is to start making up any additional dialogue. By the time you audition for a commercial the script has already gone through the ad agency's legal department. Their job is to make sure that there aren't any copyright infringements. The agency has the copy the way they want it, so don't try to improve it by adding dialogue to it.

The way to tag a spot is to look for the next, most logical action to take and then take it. Example: if the commercial is about the virtues of So-and-So's Luncheon Meat, and you're holding a sandwich (real or imagined) made with The Hero luncheon meat, when you finish the copy take a bite of the sandwich. That will be your tag, your signal that the story is over.

> *The way to tag a spot is to look for the next, most logical action to take and then take it.*

If the product is *Newsweek* magazine and you're holding a copy of the magazine in your hand, when you've finished the scripted dialogue open the magazine and start reading. If you tag the spot properly, and sometimes it will be something as simple as nodding your head, the people who make the casting decisions will see that you're an actor who knows what he's doing. Not only did you create a beginning but you also knew when the story was over and you created an ending. This will put you light years ahead of most of the other actors auditioning for the same spot.

EXERCISE

Read over several of the pieces of copy you've been working on and determine if the tag has been written into the copy, either in the dialogue or an action indicated in the script.

When you find ones with ambiguous endings, figure out the next most logical step to take and take it. This should be an action; don't add any words. You can add sounds—a grunt, a moan of pleasure—but no words. If you have a camera, record your work and play it back to see if you "landed" the tag.

Don't use mirrors to monitor your work. In a mirror we see ourselves in the immediate. With a camera, in playback, we see ourselves after the fact and can analyze what we've just done. Another reason using a mirror isn't a good idea is that most of us (me included) are too concerned with what we look like to really focus on the work. Borrow a camera if you don't have one and record your work so you can watch the playback and see what you are or aren't doing. Both are important.

CHAPTER EIGHT

Embracing the Cliché

If you do what I'm about to tell you in a scene study class, most teachers would shoot you. If you do it in my scene study class, I will most definitely shoot you. But in commercials this next step is important. When you have only fifteen or thirty or at most sixty seconds to tell a story, you have to use every possible means to tell that story as completely as possible in that time frame.

What are clichés? They are a series of internationally recognized, silent gestures that we use to make a point. Want to say the food was good without speaking? What do you do? Rub your stomach and smile. Want to gesture that something is okay? Put your forefinger and thumb together to form a circle and hold it up. Or give a thumbs-up.

Add dialogue to these gestures and the meaning becomes even clearer. Touch your finger lightly to your head and then pull it away while saying the line, "I had this great idea," and this gesture, the international sign language for a light going off in your brain, reinforces the words and speeds up the telling of the story. We all use dozens of these gestures throughout the day to convey or reinforce a meaning.

...we need to make sure we're doing everything we can to enhance the storytelling.

Because commercials are abbreviated, often truncated, stories, we need to make sure we're doing everything we can to enhance the storytelling. Look for the clichés in a spot and embrace them; don't run from them. I learned this from Kate Carr when she was a casting director at Young & Rubicam in New York. Kate, I don't know where you are now but thank you for everything you taught me.

About fifty percent of the time the cliché could also be your tag. Warning: only one cliché per spot. Don't rub your stomach, lick your lips, smile and then give a thumbs-up for good food. One gesture is enough.

EXERCISE

Look at the copy we have used so far and see if there are any clichés.

Examples: For Dental Floss, the talent could, after the spot is over, give the person he is talking to a thumbs-up. For Duncan Hines, the talent could, after taking a bite of the cake, rub his stomach. Or he could simply smile and nod.

Not every spot will have a cliché and all clichés will look a little corny. Ask yourself if adding a cliché helps tell the story. If it does, use one.

Chapter Nine

Double Copy

When doing single copy you'll almost always speak directly to the camera. With double- or multiple-person copy, sometimes you'll speak directly to the camera and sometimes you won't.

When you read the script you'll discover how many characters are involved in telling the story. If there are two or more, you need to determine if the story requires an "in-the-camera" character. If it does, the in-the-camera character will be a part of the storytelling and should be included, looked at and spoken to. Usually the in-the-camera character will be the person who has the problem. Again, you should pick a real person from your life, a person who has a similar problem and put him/her in the camera.

If, however, in the story you're telling, the camera is merely an observer of the action and there is not an in-the-camera character, then neither you nor any of the other on-camera characters should ever directly address the camera. In this case one of the on-camera characters will have the problem (it could be you) and the problem will be addressed and solved in an indirect manner during the interaction between you and the other characters.

It is actually pretty easy to tell which is which. Just ask yourself, "For the story to be successful do we need to create a character to relate to?" If you do, then create that character and put him/her in the camera. If, on the other hand, the camera is merely going to record the action between you and the other on-camera characters then you don't need to create an in-the-camera character. Either way, someone's problem is going to be solved, directly or indirectly.

A word of caution when doing double- or multiple-person copy: don't get locked into

> *...you need to find as many ways as you can to stay open so the camera can see both of your eyes.*

profile. Too often actors doing double- or multiple-person copy will turn and look at another actor and then stay in those positions. If you do that, the camera can only see one of your eyes. Your eyes are the avenues to your soul. If the people

watching the playback can only see one of your eyes, you've cut off one of those avenues and the information you're trying to share will be diminished.

If, when the director is shooting a commercial, he wants to get a shot of you over the other actor's shoulder, he'll position the camera to get that shot. You don't have this luxury at the audition. The casting director isn't going to move the camera around, so you need to find as many ways as you can to stay open so the camera can see both of your eyes.

The following are two pieces of double copy that were done in my class along with the homework by the actors who performed them.

TRENDS

(TALENT: TWO WOMEN STANDING IN FRONT OF THE CHANNEL TWELVE NEWS LOGO. CHARACTER A: TWENTY-FIVE TO THIRTY YEARS OLD. CHARACTER B: EARLY FORTIES.)

A: **IF YOU WANT TO STAY IN TOUCH WITH WHAT'S HAPPENING...**

B: **BUT DON'T HAVE TIME FOR AN HOUR LONG SHOW...**

A: **TUNE INTO TRENDS.**

B: **IT'S A NEW FIFTEEN-MINUTE SEGMENT ON CHANNEL TWELVE NEWS AT FIVE.**

A: **WE'LL GIVE YOU A PEEK AT THE LATEST FASHIONS.**

B: **SHOW YOU THE BEST WAY TO LOOK FOR A JOB.**

A: **EXPLAIN THE NEWEST FADS IN DIETING.**

B: **HELP YOU PICK THE RIGHT WINE...**

A: **AND LET YOU KNOW WHAT'S HOT...**

B: **AND WHAT'S NOT IN THE LOCAL RESTAURANT SCENE.**

A: **THERE'S SOMETHING FOR YOU EVERY DAY ON TRENDS.**

B: **STARTING MONDAY ON THE CHANNEL TWELVE NEWS AT FIVE.**

This piece of copy needs an in-the-camera character. It's unlikely that the two actors would use the same person and it doesn't matter. What does matter is that each actor picks a person, someone they know who needs this information, and they put that person in the camera.

This is how the actor reading for Character A broke the copy down:

Problem: People who don't have a lot of time but want to stay up-to-date on the latest events.

Solution: A 15-minute TV news show—Trends—that will keep those people in the loop.

Friend: Alice Long. She's a single mom and a lawyer. She's always jammed, always looking for the condensed version of anything.

Substitution: The product is local news. I don't really love local news but I do love to watch Oprah so I'll use her show.

Moment Before and Banter: Except for the question to get us started, which comes from the person I place in the camera (because I have the first line), all the rest of the banter is built in; Character B supplies me with all my set-ups and I, hers.

Moment Before:
[ALICE: HOW CAN I STAY IN TOUCH WITH WHAT'S HAPPENING IN TOWN?]

A: *(L2LO – to inform)* **IF YOU WANT TO STAY IN TOUCH WITH WHAT'S HAPPENING…**

B: **BUT DON'T HAVE TIME FOR AN HOUR LONG SHOW…**

A: *(L2LO – to invite)* **TUNE IN TO TRENDS.**

B: **IT'S A NEW FIFTEEN-MINUTE SEGMENT ON CHANNEL TWELVE NEWS AT FIVE.**

A: *(L2LO – to entice)* **WE'LL GIVE YOU A PEEK AT THE LATEST FASHIONS….**

B: **SHOW YOU THE BEST WAY TO LOOK FOR A JOB….**

A: *(L2LO – to draw in)* **EXPLAIN THE NEWEST FADS IN DIETING….**

B: **HELP YOU PICK THE RIGHT WINE…**

A: *(L2LO – to tempt)* **AND LET YOU KNOW WHAT'S HOT….**

B: **AND WHAT'S NOT IN THE LOCAL RESTAURANT SCENE.**

A: *(L2LO – to guarantee)* **THERE'S SOMETHING FOR YOU EVERY DAY ON TRENDS.**

B: **STARTING MONDAY ON THE CHANNEL TWELVE NEWS AT FIVE.**

Tag: It sounds corny but because my partner has the last line, I know I'm going to be looking at her as she says that last line, so when she's done I am going to turn back to the camera and nod. This will tag the spot for me, affirming that

what my partner has just said is true and letting Alice know that this is exactly the information she wanted in the first place.

Because this is fast moving, two-person copy I know I need to stay open and say most of my lines to the camera, to Alice. I can stay in relationship with Character B by looking to her when she is saying her lines. By doing that, this two-person dialogue becomes a three-way conversation, and even though Alice has only one line—the imaginary question that starts us off—both Character B and I are directing our conversation toward her, in an attempt to solve her problem.

There are three important things to note about this piece of copy. First, both characters are more than just friends trying to solve another friend's problem; they also work for the company/product being advertised. The words "we," "our" and "us" are clues that will help you determine whether you're a friend or a spokesperson. Remember, you could be both.

Playing a spokesperson should elevate your status; it should infuse you with a sense of pride and alter the delivery of your lines. Because you work for the company, it's only natural that you would feel stronger about addressing the issue than if you were just a regular person trying to solve a friend's problem.

> *Variety is crucial in commercial copy because you're basically limited to one emotion—joy.*

The second thing to note here is that Character A has many similar Line-to-Line Objectives—"to entice," "to draw in," "to tempt;" similar, but not exactly the same. The reason you want to use different L2LOs and not repeat the same one over and over again, even though you're essentially expressing the same sentiment, is that you want to create variety. Variety is crucial in commercial copy because you're basically limited to one emotion—joy. Though seemingly similar, "to entice" is different than "to draw in" which in turn is different than "to tempt;" each lends a distinct flavor to its respective line and that helps you achieve variety.

This doesn't mean that you won't touch on sadness/disappointment, anger/frustration, confusion/angst, etc., but you'll just barely brush up against these emotions as you travel through commercial land. The only emotion you'll ever solidly land on is joy.

The third thing to note in this commercial is how Character A says she stays in relationship with Character B. She speaks directly to the camera on her lines but when Character B is speaking Character A turns to look at her. Character B does the same thing, says her lines to the camera and then turns to look at Character A when A speaks. This is how they keep the relationship between

them alive. When you do this you don't have to snap your head around as soon as you finish your line. Just let the sound of the other person's voice get your attention and turn to see what they have to say. When they've finished, turn your attention back to the in-the-camera character and say your next line. Pretty much what we do when we're having a three-way conversation. This prevents you from getting locked into profile and keeps you open to the camera for most of your audition.

> *...when "Action" is called, the two actors should turn and acknowledge each other before either one of them speaks.*

Another way to heighten the relationship between the actors is, when "Action" is called, the two actors should turn and acknowledge each other before either one of them speaks. This creates a positive bond between them before either one has said a word. Once they've acknowledged each other then the actor with the first line turns to the camera and speaks.

Here's the second two-person commercial. This one does not involve an in-the-camera character.

GRANDVIEW NATIONAL BANK

(A MAN IN HIS EARLY SIXTIES. A WOMAN IN HER MID THIRTIES.)

(BOTH STAND LOOKING AT A BEAUTIFUL PARCEL OF LAND. THE LAND IS COVERED WITH TREES AND HAS A CREEK RUNNING THROUGH IT.)

FATHER: **ARE YOU SURE THIS IS A GOOD THING?**

DAUGHTER: **WHAT, DAD?**

FATHER: **YOU AND TIM, BUILDING YOUR OWN HOUSE?**

DAUGHTER: **IT'S WHERE WE WANT TO BE.**

FATHER: **IT'S BEAUTIFUL HERE, DON'T GET ME WRONG. IT'S JUST...**

DAUGHTER: **WHAT?**

FATHER: **WELL, THE EXPENSE.**

DAUGHTER: **DON'T WORRY, SAM TOOK CARE OF THAT.**

FATHER: **WHO'S SAM?**

DAUGHTER: **OUR BANKER AT GRANDVIEW NATIONAL BANK. HE GOT TOGETHER WITH THE ARCHITECT AND THE BUILDER AND WORKED OUT THE ESTIMATE FOR THE LOAN. IT'S LESS THAN WE'RE PAYING NOW FOR OUR OLD HOUSE.**

FATHER: **REALLY?**

DAUGHTER: **WANT TO SEE WHERE YOUR ROOM IS GOING TO BE?**

(THE FATHER SMILES, HUGS HIS DAUGHTER. THEY WALK TOWARD THE TREES. AS THEY WALK, THE DAUGHTER GESTURES, SHOWING THE FATHER WHERE THE HOUSE IS GOING TO BE BUILT.)

Because there is no third person involved with this piece of copy, the actors never directly address the camera. The problem and the solution are written into the story and the consumer receives the information about the product in an inferred manner.

The actor playing the father broke the script down this way:

Problem: A person, anybody, getting in over his/her head financially.

Solution: Grandview National Bank—they will make sure that doesn't happen.

Friend: With this piece of copy there is no third person to put into the camera. At the audition I was paired up with a young woman I had never met before so I felt I needed to use a substitution for her. I have a young friend, Lena, who just graduated from medical school and the loans she took out for her education are staggering. I have genuine feelings for her and I am afraid she is in over her head.

Substitution: I never heard of Grandview National Bank before. For the product I am going to use my bank as a substitution because they have treated me very well over the years. For Sam I will use Donna, the VP at our branch who has handled several out-of-the-ordinary transactions for me. For Tim I will use a young man I was in a show with last month, Jason. He's the first person who came to mind so I'll use him. Nice guy, good actor, pleasant to work with.

Moment Before and Banter: I had the first line so I needed to come up with a question to get us started. We had a chance to rehearse in the lobby and during rehearsal I asked the woman playing the daughter to ask me, "What do you think, Dad?" She said okay and that became our Moment Before. When we went in to the audition and the casting director called, "Action" the woman playing my daughter didn't say anything but I heard, "What do you think, Dad?" and I responded with my first line of dialogue.

GRANDVIEW NATIONAL BANK

(A MAN IN HIS EARLY SIXTIES. A WOMAN IN HER MID THIRTIES.)

(BOTH STAND LOOKING AT A BEAUTIFUL PARCEL OF PROPERTY. THE PROPERTY IS COVERED WITH TREES AND HAS A CREEK RUNNING THROUGH IT.)

Moment Before:
[DAUGHTER: WHAT DO YOU THINK, DAD?]

FATHER: *(L2LO – to probe gently)* **ARE YOU SURE THIS IS A GOOD THING?**
The word "this" is used here. I used it to break up the sentence, to set the right pace, to make sure we didn't start too fast. I pointed my forefinger and looked in the direction of the property as I said it.

DAUGHTER: **WHAT, DAD?**

FATHER: *(L2LO – to clarify)* **YOU AND TIM, BUILDING YOUR OWN HOUSE?**
Substitution – Lena for the actress playing my daughter and Jason for Tim.

DAUGHTER: **IT'S WHERE WE WANT TO BE.**

FATHER: *(L2LO – to back off slightly)* **IT'S BEAUTIFUL HERE, DON'T GET ME WRONG.** *(L2LO – to prod tentatively)* **IT'S JUST...**
I wanted to play this as if she was getting a little frustrated with me, not angry, just a father/daughter thing, and I wanted to backtrack a little and come at the problem from a different direction. I didn't gesture toward the property on "here." I felt I had already used that gesture and didn't want to repeat it.

DAUGHTER: **WHAT?**

FATHER: *(L2LO – to stop beating around the bush)* **WELL, THE EXPENSE.**
This is the problem. I'm afraid my daughter is getting in over her head, biting off more than she and her husband can chew.

DAUGHTER: **DON'T WORRY, SAM TOOK CARE OF THAT.**

FATHER: *(L2LO – to inquire)* **WHO'S SAM?**
I'm not sure who she is talking about and I'm concerned. Not angry; just curious.

DAUGHTER: **OUR BANKER AT GRANDVIEW NATIONAL BANK. HE GOT TOGETHER WITH THE ARCHITECT AND THE BUILDER AND WORKED OUT THE ESTIMATE FOR THE LOAN. IT'S LESS THAN WE'RE PAYING NOW FOR OUR OLD HOUSE.**

FATHER: *(L2LO – to admire her thoroughness)* **REALLY?**

After her explanation I've gone from being concerned to being happy. To help me make this transition I used my bank and the things they had done for me (house loan, car loan, etc.) for Grandview Bank and used the VP, Donna, who works at my bank, for Sam.

DAUGHTER: **WANT TO SEE WHERE YOUR ROOM IS GOING TO BE?**

(THE FATHER SMILES, HUGS HIS DAUGHTER. THEY WALK TOWARD THE TREES. AS THEY WALK, THE DAUGHTER GESTURES, SHOWING THE FATHER WHERE THE HOUSE IS GOING TO BE BUILT.)

Tag: I don't have any more lines here but after the actress pointed out where the house was going to be I used both hands to draw out a very large room for myself. We laughed and walked toward the camera and out of frame.

Commercials without an in-the-camera character are more like a regular acting job than other commercials. In this spot the actors work together and never have to concern themselves with the camera, other than to stay open. They accomplish this by focusing on the site where the house is to be built and stay in relationship by checking in with each other. When the daughter speaks, she is looking in the direction of the house and the father is looking at her. When the father speaks, the daughter is looking at him and he is looking in the direction of where the house is going to be built. This way each actor is open on his/her lines.

> **Commercials without an in-the-camera character are more like a regular acting job than other commercials.**

Again, they didn't snap their heads around; the other person's words got their attention and they turned to see what that person was saying.

As the actor playing the father noted, however, they do have to concern themselves with some other realities of commercial acting. They have to keep the situation within the realm of joy—although the father may sense the daughter is getting frustrated with him, she never gets angry. They also have to let the audience know that The Hero product—the bank—solves the problem (the father's concern about his daughter and her husband taking on too much debt). The actor playing the father pointed this out in his notes. He said, after his daughter's explanation of how Sam and the bank were handling everything, his feelings changed. He'd gone from being concerned to being happy.

While commercial acting is different than "regular" acting, it is not so different that you can't make whatever adjustments need to be made. However,

sometimes, when you first start auditioning for commercials, it feels as if you're wearing a straightjacket. You have to learn to help someone else get what he/she wants instead of getting what you want. You have to limit yourself to one emotion. And you have to stay open. All of which can feel very restrictive. However, once you learn a few simple rules, you'll be able to spread your arms, and the straightjacket becomes a life preserver that holds you up as you learn how to navigate these very different waters.

EXERCISE

Find a few pieces of double- or multiple-person copy and ask yourself, "Does this copy need an in-the-camera character or not?" If it does, put someone in the camera and include that person in the commercial. If it doesn't, don't.

Remember, someone has the problem in the copy—and it could be you.

Work with a partner and practice looking into the camera and saying your first line. Then, when you hear your partner's voice, turn to him, look at him while he says his line(s) and then turn back to the camera to say your next line. And do this for the rest of the commercial.

If you can't find enough double copy (with an in-the-camera character), you can use a sequence of numbers or the alphabet: your line would be, "One, two, three" (or "A, B, C"); his would be, "Four, five, six" (or "D, E, F"); and so on. The important thing is to get used to turning out to the camera to be seen on your line and looking at your partner whenever he/she is saying their lines.

More Important Stuff

MIMING

Sometimes at auditions they'll have props; sometimes they'll have the actual product. Sometimes they won't have anything. If they don't have any props, then you may be asked to do some mime work. Your ability to mime may be the thing that tilts the casting decision in your favor.

The kind of miming I'm talking about isn't difficult. You don't have to be Marcel Marceau; you don't have to spend two years in mime school. Simply practice handling objects: a glass of water, a newspaper, a can of soup, a steering wheel.

Get a sense of how various objects feel in your hand, how big they are, how heavy they are. Pick up the real deal, put it down and then mime holding it. Actors who are versed in mime have a distinct advantage over actors who aren't.

Same with eating—often you'll be called upon to take a bite of an air sandwich or to sip from an imaginary cup. This is only hard if you haven't practiced it. You know the joke about how to get to Carnegie Hall, right?

Keep in mind that the thing that makes miming seem real is honesty. If you take a bite of an air sandwich, not only do you have to chew but you have to swallow as well. If you don't, if you say your next line without swallowing, then something clicks in the minds of the people watching the

> ...the thing that makes miming seem real is honesty.

playback and they label you as being dishonest. Once that happens, the rest of your audition is tainted. If you take an imaginary drink of water, then you have to swallow before you speak. Try taking a real drink of water and speaking before you swallow. Unless you're a trained ventriloquist you can't do it. The key to miming is honesty.

ENVIRONMENT

Many audition studios are converted office spaces with few amenities. You have to transcend these limitations and turn the studio into whatever you need it to be.

Sometimes the copy will tell you where you are: "Here at Jack's Chili Shack…"
Sometimes it won't. If it doesn't, don't be afraid to ask.

The environment is always at eye level. Don't look up and don't look down and don't get locked into profile…for too long. The people watching the playback need to see both of your eyes. That gives you a range of about thirty to forty degrees to the left and to the right of the camera.

A good actor using his imagination can easily turn a chair into a car, a card table into a fancy restaurant, a blank wall into a house. And so can you. I booked a national commercial because I was able to transform a dark paneled, tiny casting office into the Grand Canyon. I saw it in my mind's eye and my real eyes conveyed the message.

BODY LANGUAGE

Don't send mixed signals. Make sure your eyes and your hands are working together. If you point at something, make sure you look at it; and if you look at it, make sure you see it; and when you see it, make sure you're in relationship with it.

You don't have to look at whatever you're pointing to for long but you do have to look. And you do have to see it. If you don't, if your eyes and your hands aren't working in unison, you will confuse the auditors and split their focus: "Should I look at what he's pointing to or should I look at him?" You want to enhance your work, not detract from it.

> *…if your eyes and your hands aren't working in unison, you will confuse the auditors and split their focus…*

In most circumstances if the words "these," "those," "this," "that," "here" and/or "there" appear in your copy then you need to acknowledge the space or object those words represent. You can point to it with your finger, you can nod your head toward it, you can give it a sideways glance; just make sure you acknowledge it. "Those boys…" "That dog…" "Over there at Ralph's Big Man's Shop…"

Your body language needs to support the copy. This is not advanced physics, just good acting. Even if you have to place something behind you, look at it quickly. Quickly doesn't mean that you don't see it; it means you see it quickly and then you return to the camera. "Behind me, at Happy Joe's Discounts…" Your thumb points over your right shoulder as your head turns to look in the direction your thumb is pointing. You see Happy Joe's Discount Store behind you and you come right back to the camera. You've gone from talking to your friend in the camera to having a quick relationship with Happy Joe's and then back to talking

to your friend in the camera, all in less than two seconds. And, as odd as it may sound, we can tell from the back of your head whether or not you've seen the thing you're talking about.

Don't forget you also need to know how you feel about what you're talking about and/or looking at. The people watching the playback will pick up on whatever it is you're feeling. And if you're not thinking anything, not feeling anything, they'll pick up on that too. This is another reason why substitutions are so crucial.

Here is a piece of single copy to illustrate this:

OMEGA BATTERIES

(LONG SHOT. DEAD OF WINTER. DESOLATE STRETCH OF HIGHWAY. THE WIND HOWLS; THE SNOW BLOWS.)

(A STALLED CAR IS PARKED ON THE SHOULDER OF THE ROAD. A TOW TRUCK IS PARKED FACING THE STALLED CAR. THE HOOD OF THE CAR IS OPEN AND BATTERY CABLES EXTEND FROM THE TOW TRUCK INTO THE OPEN HOOD OF THE CAR.)

(THE TOW TRUCK DRIVER—A BIG MAN IN HIS LATE THIRTIES TO EARLY FORTIES—ATTACHES THE BATTERY CABLES TO THE CAR'S BATTERY.)

(THE TOW TRUCK DRIVER TURNS TO THE CAMERA.)

DRIVER: **I GOT STRANDED ONCE. IT WAS WINTER; I LEFT MY LIGHTS ON. IN THIS WEATHER, IF YOU HAVEN'T GOT AN OMEGA BATTERY, YOU HAVEN'T GOT A CHANCE. THIS WAS ME, I'D MAKE SURE I HAD AN OMEGA.**

(THE DRIVER TAPS ON THE WINDSHIELD OF THE CAR. THE CAR'S ENGINE TURNS OVER AND ROARS TO LIFE.)

Here's the same piece of copy after the actor did his homework:

Problem: People left stranded by a faulty car battery.

Solution: Omega batteries.

Friend: Jack Johnson. He got stranded at his kid's soccer game last week for this very same reason; he left his lights on. Not exactly life or death but he did have four kids that needed to go to four different places.

Substitution: Car batteries don't really mean all that much to me; it starts my car, I drive. And one brand is pretty much the same as another. So, I need to

use a substitution. I'm a carpenter by trade so I'll use the new power saw I just bought. And the fact that I got it on sale makes me love it all that much more.

Moment Before:
[JACK: YOU EVER BEEN STRANDED?]

DRIVER: *(L2LO – to sympathize)* **I GOT STRANDED ONCE.**

[JACK: WHAT HAPPENED?]

DRIVER: *(L2LO – to recall)* **IT WAS WINTER; I LEFT MY LIGHTS ON.**

[JACK: BAD, HUH?]

DRIVER: *(L2LO – to warn with genuine concern)* **IN THIS WEATHER, IF YOU HAVEN'T GOT AN OMEGA BATTERY, YOU HAVEN'T GOT A CHANCE.**
Physical gesture on "In this weather..." – point back over my shoulder to indicate the snowstorm. Product is mentioned here; need to use my substitution.

[JACK: WHAT SHOULD I DO?]

DRIVER: *(L2LO – to proclaim)* **THIS WAS ME, I'D MAKE SURE I HAD AN OMEGA.**
Physical gesture on "This was me..." – nod my head toward the driver behind the car's windshield. Come back to camera for the rest of the line. Product mentioned again, use substitution again.

(THE DRIVER TAPS THE WINDSHIELD OF THE CAR. THE CAR'S ENGINE TURNS OVER AND THEN ROARS TO LIFE.)

Tag: After the car starts, I turn and give a "thumbs-up" to the camera. If the camera is still running I'll mime detaching and rolling up the cables.

With this piece of copy the actor is talking directly to the camera. That means the person he is talking to would be out in the storm with him. This doesn't necessarily make any sense, but the audience's ability to suspend their disbelief rests with the actor. It is the actor's job to make the unreal real, and the better we are at doing it, the less the audience will question the plausibility of an implausible situation.

> *...the audience's ability to suspend their disbelief rests with the actor.*

Think *Star Trek* and you'll realize what I'm talking about. The same thing applies to commercials. Our job isn't to question the circumstances; our job is to make those circumstances work.

EXERCISE

Read over several pieces of copy and see if you can tell what the environment is. Look for things you can do to "establish" that environment. Remember to keep the environment at eye level and to make sure the camera is seeing both of your eyes for most of the time.

Make sure you're not sending mixed signals. Look for the words "these," "those," "this," "that," "here," "there," and look for ways you can physically reference the things those words are referring to. For "this boy" or "that repair shop" you need to look at them, see them and reference them. If you don't, then it is very likely you will confuse the people watching the playback.

Pick up a basketball, a slice of pizza, a telephone, and get a sense of how each one feels. Then mime the activity. Pick up a real coffee cup and take a real sip. Then pick up an imaginary cup and take an imaginary sip. Don't forget to blow on it if it's hot. And after you take a sip, swallow.

Pick several non-related things: a box of tissue, your Uncle Bill, a box of Wheat Chex, your favorite team winning the World Series. Figure out what feeling you want to convey for each person, object or situation and then communicate each one of those feelings. Maybe the tissue is Brand X.

Because the camera can see what you're feeling, what you're thinking is extremely important. So make sure you engage in an active thought process that produces the feeling you want to

convey. When you do, the camera will pick up on that feeling and broadcast it. You don't have to worry about projecting the feeling; the camera will do it for you. Your job is to generate the feeling; so, please, no overacting!

The Dreaded Interview

What if there isn't any copy? Sometimes commercials are made up of short vignettes that don't have dialogue. Or the dialogue is done in voice over. In those cases you still need to audition, but the audition is going to be different. You're going to be asked an interview question.

Casting directors don't do this to torture you. Most actors won't agree with this, but it's true. Casting directors do it because they know their clients want and need to see your personality. The way you slate will give them some information but not enough. The ad agency is going to make a substantial investment in you—millions and millions of dollars—and they're entitled to know what they're getting.

Hence the dreaded interview. These questions are usually fairly inane: "Tell us something about yourself." "What are you doing this weekend?" "What's your favorite color?" But while the questions themselves may not seem important, the way you answer them is.

How will you know if they're going to ask you an interview question? If you go to an audition and there isn't any copy, or if there's only one short line of dialogue, you're probably going to be asked a question. Then you'll have fifteen to

> *... while the questions themselves may not seem important, the way you answer them is.*

twenty seconds to answer it. Five seconds isn't long enough and sixty seconds is way too long. You have less than a half a minute to make them fall in love with you.

Here are some guidelines to facilitate that:

- Remember, answering interview questions for commercials is a chance to show off your personality. Make sure yours shines.

- Your answers should be in story form. "Blue is my favorite color because…" is the beginning of a story. Your stories should be short, interesting, and (ideally) humorous.

- *What* you say isn't nearly as important as *how* you say it.

- Don't mention anything about acting unless specifically asked. In the thousands of commercial auditions I've been on, I've been asked about my acting career twice. (You'd think they would be more interested in our fabulous professional lives and the wonderful roles we've played, but they aren't.)

- Talk to the camera. Put your best friend in the lens and talk to him/her. That way, regardless of how many times you've told your story before, your best friend will still be happy to hear it.

- Make sure you enjoy telling your story. If you don't enjoy it, why should they?

- Make the story cohesive; stick to one subject. You don't have enough time to introduce five or six thoughts and then tie them all together.

- Don't appear desperate. Don't talk about the job at hand unless specifically asked. (I actually said this at a Ford Explorer audition: "If you hire me for this spot I'll go out and buy a Ford." Needless to say, I didn't book the job.)

- Your stories don't have to be true. Invention—a much kinder word than lying—is the thing that keeps most of us from being boring. However, if you are going to infuse your story with an "invention," make sure it has at least a grain of truth in it.

- Don't lie about your skills. If you're asked about a specific skill, don't tell them you're an expert if you aren't. However, you don't want to slam the door closed either. Let them know that whatever it is they want you to do you're willing to learn. "Gosh, no, I don't rumba but I've always wanted to learn." It's important to keep the door of possibility open. (Years ago I auditioned for a PGA spot. After my audition the director and I had a great conversation and as I was leaving (my hand was literally on the doorknob), he asked me, "John, do you play golf?" I turned and without hesitation said, "I don't. But I look like I do." He not only hired me, he also changed his shot list so I never actually had to swing a club.) Keep the door of possibility open.

- If you get a question you aren't expecting, repeat it to give yourself time to come up with an answer. This is a lot better than you standing there looking all "duhhhh."

- Remember the real question—no matter what they ask you—the real question is, "We're about to invest two to ten million dollars in this project. Are you the right person for the job?" Let them know, by the way you answer the question, that you are absolutely the right person for the job.

EXERCISE

Create a list of questions: "How's your day going?" "Any plans for tonight?" "Seen any great movies lately?" and answer them. Keep your answers short, your enthusiasm high and enjoy telling your stories.

CHAPTER TWELVE

More Really Important Stuff

STAY POSITIVE

Your audition starts before you walk into the casting director's office and it ends after you get back on the street. If the casting director asks how you are, you're great. It doesn't matter if your husband just ran away with his secretary or your cat just died; you're great.

They aren't asking you for a blow-by-blow account of your day, so don't give it to them. They're simply being polite. You can cry about your divorce later. You can mourn your cat another day. You have three to five minutes to win the job. Don't ruin it by indulging in the melodrama of your life.

STAY IN RELATIONSHIP

Make sure you have done as much of the homework as you can before you get in front of the camera: know what your Moment Before question is, what your L2LOs are, what the banter is, and how you're going to tag the spot.

Once you're in front of the camera your major task is to stay in relationship—with the person you're slating to, with the person you've put in the camera to deliver the dialogue to, with your audition partner(s), with the product, and with whatever events might be mentioned.

> *...the more engaged you are in the relationships you're creating, the better your storytelling will be.*

Never forget, the camera knows what you're thinking, so the more engaged you are in the relationships you're creating, the better your storytelling will be.

MAKE SURE YOUR BODY
GOES TO THE AUDITION WITH YOU

Learning the mechanics of a new technique can be a very cerebral experience. This technique is no exception. Actors, when learning new concepts, often go into their heads trying to remember everything that's been thrown at them and their bodies get left behind.

Nerves, especially at an audition, escalate an already tense situation. But there are three things you can do to make sure your body shows up at the audition along with your mind.

The first is to jump up and down. Really. Jump up and down. An interesting thing happens when we jump: the mask that most of us hide behind comes off. You want that mask off, you want to make sure that the real you is the one who shows up.

Next is to laugh. If you're laughing, you're breathing. There is nothing more painful than to watch an actor who isn't breathing. The auditors become concerned in all the ways you don't want them to be concerned if you aren't breathing. So, don't be afraid to laugh. The laughing doesn't mean that anything is funny; it is merely a way to engage your body. However, if you do laugh and it produces a smile, that's not such a bad thing. We are talking about commercials.

I suggest you do one or the other or both of these first two things—jumping and laughing—before you slate. If you don't get the chance to do either before the camera is turned on then laugh and/or jump anyway. Don't be concerned that the people watching the playback of your audition will think you're weird because you're jumping and laughing. Better they think that and then see you have a great audition than for them to think you're "dead" and not connected to your body.

> *They have to go on at a hundred percent with their characters—minds and bodies—fully engaged and functioning.*

Actors (and athletes) do this all the time. Before the cameras roll or when they're standing backstage waiting to go on, actors are moving their bodies, jumping up and down, swinging their arms. They do this because they know they can't afford to go on at seventy percent. They have to go on at a hundred percent with their characters—minds and bodies—fully engaged and functioning.

The third way to make sure you're connected to your body is to use a yoga exercise called *mula bandha*. Ladies, think Kegel muscle; men, think the muscle under your testicles. It may seem strange mentioning this in an acting book, but it works. In fact, it may become your new best friend. Squeezing those muscles

sends a bolt of energy through the body that puts a sparkle in your eye. And that sparkle says, "I'm here."

Remember, the eyes are the avenues of the soul and one of the messages you want to send when auditioning is "I am present. My mind, body and soul are engaged and I'm ready to work." Engaging those muscles will make that happen.

A word of caution regarding *mula bandha:* go slowly when you first start. A lot of people don't use those muscles that often and it takes a little bit of time and practice to get them into shape.

MAKE STRONG CHOICES

Find a way to keep the stakes high. If you fall into the trap of "Oh, this is only a commercial and it's not all that important," you run the risk of coming across as if you don't care. Indifference is not only hard to play, it's boring to watch. Your job as a commercial actor is to solve someone else's problem. If you make the problem important, it'll be easier to solve.

Commercials are by their very nature artificial. Nobody talks that way in real life, but when you're auditioning for a commercial, whatever you're saying needs to be said with complete sincerity. Anything less and you won't get hired. And as one of my teachers told me years ago, "As soon as you learn how to fake sincerity, you've got it made."

DON'T MEMORIZE – NOT YET

One way actors shoot themselves in the foot is by trying to memorize the script too soon. Do the other work first; it turns the script into a story in which things happen in a logical sequence. One line will automatically lead you to the next. That makes memorizing easier.

Remember, the story, especially at the initial audition, is more important than the words. If you spend all of your time trying to memorize the words, you may not fully comprehend the story or the best way to tell it. Get to your audition early, do all the other work and once you know what you're doing, then you can start memorizing your lines. If you're going to make a mistake it's better to screw up a couple of the words than to screw up the story.

> ...the story, especially at the initial audition, is more important than the words.

Don't be afraid to use the boards. If there's dialogue, most commercial auditions (and all union commercial auditions) will have a board near the camera

with the dialogue written on it. The trick is to not get stuck on the board and end up reading every line off of it. A way to avoid this is to learn how to look at the board and see phrases instead of individual words. You go to the board, pick up a phrase or an entire sentence, come back to the camera, reconnect to the person you were talking to and deliver that line. This is a skill you can learn but like anything else it takes practice.

If you get jammed at the audition, if you get there late, or if they call you in early and you don't have a lot of time, memorize the first and the last lines. That way you can deliver those lines with confidence directly to the person you've placed in the camera.

SPEED KILLS

Going too fast lets everyone know you're nervous. Nobody wants a nervous actor on the set; there is way too much money involved. Good actors know that it takes time to create solid relationships. Good actors know they're telling a story. They know they have to create subtext for their lines, and they have to listen to the other characters. All of this takes time.

> *If you speed through the copy, you won't give yourself time to connect to the person you're talking to...*

If you speed through the copy, you won't give yourself time to connect to the person you're talking to—you can't hear their banter that sets up each one of your lines; you can't shift from one L2LO to another—and the audition will be over before you know it.

You don't get a prize for telling a thirty-second story in ten seconds. Thirty seconds is a lot longer than you think. If you have the opportunity, put yourself on camera. Look straight into the lens, don't talk, and have someone time thirty seconds for you. You'll discover that it is more than enough time to tell a story.

ASK FOR A REHEARSAL

Actors will often go on a commercial audition, a job that could pay their rent for the next two years, and they don't even think to ask for a rehearsal. They expect that somehow, magically, the gods will smile on them and they'll be perfect. And then when they aren't, they blow the whole thing off, saying, "Commercials—I don't know why I bother to go. I never book." No kidding!

You need to rehearse, in the room. Every audition I've ever been on, I have been perfect…IN THE LOBBY. There's no pressure…IN THE LOBBY. You're sitting in

a corner by yourself mumbling your lines at less than half volume. Then suddenly you're in the audition room staring at a one-eyed, three-legged monster and ninety-five percent of all the things you were working on have flown out the window.

Asking for a rehearsal takes courage. As actors we don't want to make waves; we don't want to appear to be difficult. I'm not suggesting that you be difficult. I'm suggesting that you take care of yourself. You got dressed, drove or took the

> *Every audition I've ever been on, I have been perfect...IN THE LOBBY.*

subway to the audition, did your work; all for what? To do a bad job? If that's the case, stay home. Save everyone, including yourself, a lot of time and effort.

A rehearsal is a vital piece of the audition process. By asking for a rehearsal you'll have a chance to say the words out loud in the room. By asking for a rehearsal you might get some feedback and pick up some additional information you didn't have before. If you don't ask for a rehearsal then the people who watch your playback are judging you on your first take. Good job, bad job—you've made an impression.

If it's a bad impression, it will be hard for them to get over it. And if it is really bad, they'll fast-forward to the next person. Even if you do a great job on your second take, chances are they won't stick around to see it.

Remember why you're there: you're there to book a job. And there are a lot of people rooting for you. Your agent is rooting for you; the casting director is rooting for you; the ad agency people are rooting for you; the client is rooting for you; the roommate you owe money to is rooting for you. Everybody is rooting for you. They all want you to do a great job. If you do a great job their problem is solved.

It is very possible that at some point during the day the casting director will fall behind schedule. If you were on time and you've done everything you were supposed to do, don't let their time problem become your problem. You don't have to be a jerk about it; you want to be as diplomatic as you can, and you want to make sure you get a rehearsal.

If they're hesitant say, "I know you want me to do the best job I can, and if you would let me have a rehearsal I could do that." That's exactly what they want: they want you to do a wonderful job. By asking for a rehearsal in this manner it takes all the pressure off of you. You're merely reminding them of why they asked you to audition in the first place.

For the most part casting directors are decent, hard working people. Casting a spot isn't easy and casting directors are often placed in a difficult position. They have to take the "as-yet-not-completely-realized" idea that the ad agency is trying

to convey and then find the talent that will bring full expression to that idea. This is hard. Show them how professional you are by doing your job well and they'll be more inclined to give you a rehearsal when you ask for one.

If you ask for a rehearsal, most of the time the casting director will stop the camera and allow you to rehearse. Sometimes the camera will continue to roll, but even if it does, because you asked for a rehearsal, you've already set it up in the minds of the people watching the playback that the next thing they're going to see is a rehearsal, not a performance. This is an important distinction.

If the casting director gives you a rehearsal, be respectful. Do everything in your power to incorporate any feedback you get. You asked for help. You got it. Now use it.

KNOW YOUR FRAME

It's also important to ask for your frame—you need to know how much of you the camera is seeing. If you're planning to use a prop, you need to know if that prop is going to be in the frame. There's no sense in holding a box of Cheerios in front of your stomach if they're shooting a close-up of your face. You need to know what part of your body is working, what exactly the camera is seeing.

The tighter the frame the less you'll need to do in order to get your point across. Think about it this way: how expressive would you have to be to communicate an idea to someone standing twenty feet away. And how expressive would you have to be to convey that same information if the person was just two feet away.

IMPROV

Many years ago actors would occasionally be asked to improvise during their commercial auditions. And actors, being the obliging people they are, would do it. Then somewhere in the process an improvisation one actor had come up with during the audition would be used in the commercial, but not necessarily by the actor who created it. Another actor would be hired and directed to "use this bit" (either a piece of business or a line of dialogue or both), and the actor who created the "bit" in the first place not only didn't get the job but wasn't compensated for his/her creativity. This behavior was reported to the Screen Actors Guild and SAG passed a rule that actors could no longer be asked to "improv" at auditions.

Nowadays casting directors may ask you to "loosen it up" a little at your audition. This is another way of asking you to improvise without actually saying the word. Either way, it puts you between a rock and a hard place, and you have to

decide: "To improv or not to improv?" If you don't, you may come across as being uncooperative; if you do, you run the risk of having your creativity "borrowed." Unfortunately, this is a line you have to draw for yourself.

Non-union actors face an even more precarious position when it comes to improvising at an audition because they don't have a powerful union watching their backs.

EXERCISE

Make sure your body shows up with you. Practice laughing and jumping. Sounds weird, right? But if you have a camera you'll see what I'm talking about. First slate without laughing or jumping and then, after you've done your impression of a hysterical kangaroo, slate again. You should see a huge difference.

The initial results may be too "big" to use for your slate but you will see a sparkle in your eye you didn't have before. Once you have the sparkle it is very easy to modify the amount of laughing and jumping you'll need to do to make your slates stand out.

And don't forget *mula bandha*. That will put a twinkle in your eye for the rest of the audition.

Use the boards. Write out a series of commercials. Use poster-size paper (butcher paper will do). Use commercial copy you haven't worked with before. Write it out and tape it next to the camera. Practice looking from the board to the camera. Work on picking up phrases and whole sentences instead of just one word at a time.

Slow down. Using the same pieces of copy, write out the banter and then make sure you hear the banter before going on to the next line. This is easier when you're doing double or multiple copy because you can't jump the other character's lines. Give your friend, the one you wrote the banter for, the same courtesy.

The Wrap Up

YOU HAVE MORE POWER THAN YOU THINK

The last but most important thing to remember is that at a commercial audition you have a lot of power. It may not seem that way, but it's true.

You have power because, if you've done the homework, you know all the pieces to the puzzle. You know how the commercial's going to start and how it's going to end. You know what the problem is and you know what the solution is. You know what the relationships are and you know how you feel about each one. You know what your frame is and what the camera is seeing. You know what physical actions are needed and when and how you're going to execute them.

You know who you're talking to you and what you're going to say to them. And you know what they're going to say to you. Heck, if you've done the banter right you've written half of the script.

All of this knowledge puts you in an advantageous position, light years ahead of the other actors auditioning for the same spot. I trust you will use this newfound power wisely. You never need to make anyone else wrong in order for you to be right. Let the quality of your work speak for itself. At the end of the day, after luck and all the other fickle forces have been factored in, talent ultimately wins out.

> *Talent enhanced with technique is an unbeatable combination.*

Talent enhanced with technique is an unbeatable combination. A shortstop will practice an endless number of hours to perfect playing his position. He doesn't get to tell the batter where he wants the ball hit or how hard to hit it. He plays each ball as it comes. It's the same for actors. Your responsibility is to do the best job you can regardless of the material you're given. Sometimes you'll be handed diamonds; other times, dirt. What you do with it is up to you.

Be the best actor you can be. Whether you're auditioning for a commercial or playing a small role in your community theatre, co-starring in a Broadway show or playing the lead in a feature film, know there is value in what you do. Honor your craft and be proud of your work.

Practice Copy

Here are several pieces of copy with plenty of room for you to add in your work, i.e., relationships, the Moment Before, banter, L2LOs, tag, etc.

ROUND-UP BARBECUE SAUCE

(TALENT: MAN AT AN OUTDOOR GRILL, COOKING)

TALENT: **THE SECRET TO GOOD BARBECUE IS THE COOK.**

AND THE SECRET TO BEING A GOOD COOK IS KNOWING WHAT SAUCE TO USE.

SO, IF YOU WANT TO MAKE REALLY GOOD BARBECUE, USE ROUND-UP BARBECUE SAUCE.

GUARANTEED, YOU'LL BE THE BEST COOK ON THE BLOCK.

CINCH IT

(TALENT: WOMAN, MID FORTIES, IN KITCHEN, CLEANING)

TALENT: **CLEANING ISN'T THE PROBLEM;
HAVING TO CLEAN THINGS TWICE IS.**

**FIRST YOU USE A SPRAY THAT REMOVES THE GREASE...
AND THEN YOU HAVE TO USE A GLASS CLEANER
TO GET RID OF THE RESIDUE THE SPRAY LEFT BEHIND.
SO...WHAT I DO NOW IS...USE CINCH IT CLEANER.**

IT GETS RID OF THE GREASE AND THE STREAKS ALL IN ONE STEP.

DON'T CLEAN IT TWICE...CINCH IT ONCE.

ATLANTAS TELEVISION

(TALENT: SALESMAN OR SALESWOMAN IN SHOWROOM)

TALENT: **ATLANTAS ARE THE BEST TELEVISIONS IN THE BUSINESS.**

FROM 9 INCHES TO 60 INCHES,
NOBODY GIVES YOU A BETTER PICTURE.

AND NOW THROUGH DECEMBER 25TH, WE WILL GIVE YOU 25% OFF
EVERY ATLANTAS TELEVISION SET YOU BUY.

THAT'S RIGHT, 25% OFF EVERY SET.

NICOTEAM

(TALENT: MAN OR WOMAN IN OFFICE. SEVERAL TEAM MEMBERS WORK THE PHONES IN BACKGROUND AS TALENT TALKS)

TALENT: **IF YOU'RE AN EX-SMOKER LIKE ME YOU KNOW HOW HARD IT IS TO QUIT SMOKING.**

ESPECIALLY IF YOU'RE DOING IT ALONE.

THAT'S WHAT MAKES NICOTEAM SO UNIQUE.

NICOTEAM IS MORE THAN JUST A PATCH.

NICOTEAM IS A GROUP OF VOLUNTEERS, EX-SMOKERS LIKE ME, AVAILABLE 24/7 TO HELP TALK YOU THROUGH YOUR CRAVINGS.

SO, IF YOU'RE READY TO QUIT SMOKING...PICK UP A PACK OF NICOTEAM PATCHES AT YOUR LOCAL PHARMACY AND PUT YOUR TEAM TO WORK.

NICOTEAM.

VISION CLEAR

(TALENT: MAN OR WOMAN IN VISION CLEAR OFFICE)

TALENT: **WHEN EVERYTHING'S BLURRY LIFE ISN'T MUCH FUN.**

STOP IN AT VISION CLEAR AND WE'LL GIVE YOU AN EYE EXAM FOR FREE.

AND IF YOU NEED GLASSES...WELL, THAT'S WHAT WE DO.
DON'T WAIT TOO LONG...OFFER EXPIRES SOON.

CHAMPION RAISIN BRAN NUTRITION BARS

(TALENT: MAN OR WOMAN, MID THIRTIES. FIT, IN GOOD SHAPE. OUTDOORS; CAMPING SETTING IN BACKGROUND)

TALENT: **IF YOU'RE A GET-UP-AND-GO PERSON YOU WANT A BREAKFAST THAT MOVES WITH YOU.**

CHAMPION RAISIN BRAN NUTRITION BARS ARE PACKED WITH ALL THE VITAMINS AND NUTRIENTS YOU'LL NEED TO KEEP YOU GOING ALL MORNING LONG.

AND THEY TASTE GOOD TOO.

CHAMPION RAISIN BRAN NUTRITION BARS.

DAILY LOTTERY

(TALENT: MAN OR WOMAN. CHARACTER, QUIRKY)

TALENT: **QUICK, GET A PENCIL.**

THREE OF THESE LUCKY NUMBERS WILL WIN $500.00 IN TONIGHT'S DAILY THREE DRAWING.

HURRY, WRITE 'EM DOWN.

GET IT?

GOT IT?

GOOD.

Here's a template to use when breaking down single person copy. If your copy is longer than five lines add as many L2LO and Banter elements as you need. You get the idea. There will only be one Moment Before and one Tag (if necessary).

PROBLEM:

PERSON YOU'RE TALKING TO:

MOMENT BEFORE:

L2LO:
COPY:

BANTER:

L2LO:
COPY:

BANTER:

L2LO:
COPY:

BANTER:

L2LO:
COPY:

BANTER:

L2LO:
COPY:

TAG:

LEARY'S STEAK HOUSE

(TALENT: COUPLE, EARLY THIRTIES, SITTING IN A RESTAURANT)

WOMAN: **CAN WE AFFORD THIS?**

MAN: **YES.**

WOMAN: **DID YOU GET A RAISE?**

MAN: **NO.**

WOMAN: **A BONUS?**

MAN: **NO.**

WOMAN: **THEN WHAT ARE WE DOING HERE?**

MAN: **IT'S OUR ANNIVERSARY.**

WOMAN: **I KNOW BUT IT LOOKS SO EXPENSIVE.**

MAN: **NOTHING'S TOO GOOD FOR MY BABY.**

(THE WOMAN SWOONS)

ANNOUNCER (VO): **LEARY'S STEAK HOUSE SPECIAL. STEAK AND LOBSTER FOR ONLY $15.95.**

TOWER BANK CARD

(TALENT: MAN, EARLY THIRTIES; WOMAN, EARLY TWENTIES; HAVING LUNCH)

MAN: **SO, HOW ARE YOU DOING?**

WOMAN: **THINGS ARE GOOD.**

MAN: **MOM AND DAD WERE AFRAID...**

WOMAN: **OF WHAT?**

MAN: **YOU KNOW. YOUNG WOMAN, BIG CITY, NEW JOB. THEY WERE AFRAID MONEY MIGHT BE A LITTLE TIGHT.**

WOMAN: **I'M GOOD.**

(WAITER PUTS CHECK ON TABLE. MAN REACHES FOR IT)
MAN: **HERE, I'LL TAKE CARE OF THAT.**

WOMAN: **NO WAY. I'VE GOT IT.**
(SHE PLACES A TOWER BANK CARD ON THE CHECK. MAN PICKS UP THE CARD AND LOOKS AT IT)

MAN: **TOWER BANK, HUH? I'M GOING TO LET MOM AND DAD KNOW THEY CAN STOP WORRYING.**

WOMAN: **YOU CAN STOP WORRYING, TOO.**

MAN: **ME? I WASN'T WORRIED.**

WOMAN: **YEAH, RIGHT.**

PETERSON'S YOGURT

(TALENT: MIDDLE AGED COUPLE ON A FIRST DATE. TALENT SHOULD BE PREPARED TO READ BOTH PARTS.)

ONE: **TASTE?**

TWO: **FROZEN YOGURT? NO, THANKS.**

ONE: **IT'S NOT JUST YOGURT, IT'S PETERSON'S YOGURT. IT TASTES LIKE...**

TWO: (TASTING) **OH, WOW! REAL ICE-CREAM.**

ONE: **IT'S NON-FAT AND ONLY TEN CALORIES.**

TWO: **TEN CALORIES?**

ONE: **YEP.**

TWO: **I GUESS THIS IS THE END.**

ONE: **THE END?**

TWO: **YEAH. THE END OF ICE CREAM AS I KNOW IT. AND THE BEGINNING OF PETERSON'S.**

JORDAN'S FISH & CHIPS

(TALENT: CUSTOMER, MAN, EARLY FORTIES, SEATED AT A RESTAURANT. WAITRESS, ANY AGE, SETS A PLATE DOWN IN FRONT OF HIM)

CUSTOMER: **EXCUSE ME, I DIDN'T ORDER THAT.**

WAITRESS: **YES, YOU DID.**

CUSTOMER: **NO, I DIDN'T.**

WAITRESS: **YOU DIDN'T ORDER A JORDAN'S FISH AND CHIPS BASKET?**

CUSTOMER: **THAT'S NOT A JORDAN'S FISH AND CHIPS BASKET.**

WAITRESS: **YES, IT IS.**

CUSTOMER: **BUT IT HAS COLE SLAW AND EXTRA FRIES.**

WAITRESS: **THAT'S THE WAY JORDAN'S FISH AND CHIPS BASKETS COME NOW...WITH COLE SLAW AND EXTRA FRIES...FOR THE SAME PRICE.**

CUSTOMER: **SAME PRICE?**

WAITRESS: **SAME PRICE.**

CUSTOMER: **OH...YOU KNOW, I THINK I DID ORDER THAT.**

BEGALMAN'S

(TALENT: TWO WOMEN SIT ON A BENCH IN A SUBURBAN MALL.)

ONE: **WHAT A HUGE MALL. I CAN'T GET OVER THE NUMBER OF SHOPS.**

TWO: **I TOLD YOU.**

ONE: **YOU'D THINK WITH ALL THESE STORES I COULD FIND A PAIR OF SHOES I LIKED.**

TWO: **I KEEP TELLING YOU, YOU'RE LOOKING IN ALL THE WRONG PLACES. THE ONLY PLACE TO BUY SHOES IS AT BEGALMAN'S.**

ONE: **BEGALMAN'S IS A DEPARTMENT STORE.**

TWO: **YEAH, BUT THEY STARTED OUT AS A SHOE STORE. THEY'RE FAMOUS FOR THEIR SELECTION. AND FOR HAVING EVERY CONCEIVABLE SIZE. EVEN YOURS.**

ONE: **CUTE. WHY DIDN'T YOU TELL ME THAT BEFORE WE WENT TO TWENTY-EIGHT DIFFERENT SHOE STORES?**

TWO: **I THOUGHT EVERYONE KNEW ABOUT BEGALMAN'S.**

ONE: **NOW EVERYONE DOES.**
(TALENT ONE GETS UP AND WALKS AWAY.)

TWO: **HEY, WAIT FOR ME.**

SOYMATES

(TALENT: TWO WOMEN AT THE GYM TALKING TO A FRIEND. FRIEND IS IN THE CAMERA.)

A: **WOW. YOU LOOK GREAT. DOESN'T SHE LOOK GREAT?**

B: **YEAH, GREAT!**

A: **LOSING WEIGHT, TONING UP.**

B: **LOOKING HOT!**

A: **BUT ARE YOU DENYING YOURSELF CHOCOLATE?**

B: **DON'T WANT TO DO THAT.**

A: **AND YOU DON'T HAVE TO.**

B: **NOT WITH SOYMATES DELICIOUS DESSERTS. SOYMATES COME IN MOCHA FUDGE...**

A: **CHOCOLATE ROYALE...**

B: **AND DOUBLE MINT CHIP.**

A: **THEY'RE SO GOOD YOU'LL FORGET THEY'RE HEALTHY.**

B: **SO GOOD.**

COMMUNITY RECYCLING

(TALENT: TWO MEN, NEIGHBORS, PUTTING THEIR TRASH OUT ON THE CURB FOR PICK-UP. MAN #1 IS IN HIS FORTIES; MAN #2 IS YOUNGER)

1: **THAT'S QUITE A STACK OF NEWSPAPERS YOU'VE GOT THERE.**

2: **JUST A WEEK'S WORTH.**

1: **YOU'RE GOING TO RECYCLE IT, RIGHT?**

2: **WHAT FOR? SO IT CAN GET PILED UP SOMEWHERE ELSE?**

1: **YOU DON'T THINK IT COULD BE MADE INTO NEW PRODUCTS?**

2: **WHAT CAN YOU MAKE OUT OF OLD NEWSPAPERS?**

1: **WELL, HOW ABOUT NEW NEWSPAPERS?**

2: **OH, YEAH. I HADN'T THOUGHT ABOUT THAT.**

ANNOUNCER (VO): **RECYCLING. IT JUST MAKES SENSE.**

The reviews are in on John's new book:
The Science & Art of Film Acting

"Film acting is, indeed, a science and an art. How many times has a young actor gone to see a Meryl Streep or Johnny Depp film and marveled at their ability to communicate a difficult or emotional scene so naturally? Luckily for the reader, John Howard Swain demystifies a medium that for many actors proves to be daunting and elusive. The Science & Art of Film Acting should be on the shelf of every actor hoping to have a career in film and television." **Jamie Harris, Agent, Clear Talent Group**

"One of the dichotomies of acting is that, while it is difficult to do, it is even more difficult to teach. John Howard Swain understands the actor's challenges, and he understands filmmaking. He combines his knowledge of both in an invaluable handbook of practical, manageable techniques for bringing a character to life on the screen. The Science & Art of Film Acting should be required reading for actors new to film, and experienced actors will be gratified to find the tools of their trade so comprehensively presented in one volume." **Mike Langworthy, Golden Globes Award-Winning Writer**

"In John's book he takes something that can be so complex and makes it easy to understand. He's developed a wonderful technique that allows actors to do honest and compelling work on camera." **Fred Rubeck, Department Chair, Performing Arts College, Elon University**

"Trusting your instincts is as important a tool to the actor working on camera as it is for the director to have film in the camera. In John's new book he lays out a no-nonsense technique that helps the actor create the groundwork necessary to give birth to those instincts. I have used John's techniques with great success when teaching student actors the in's and out's of acting for the camera." **Charles Dougherty, Director, US Performing Arts**

"I have had the good fortune to work with John as both a teacher and a director and I've also had the pleasure of watching him work as an actor. The unique thing about his approach to the work is that he can see it from all sides. He is able to take what he knows and assist the actor so that his performance is not only clearer but also more powerful. It truly is a marriage of science and art that makes acting seem effortless. How lucky for actors that John has written this book to share his insights!" **Summer Crockett Moore, Producer, Choice Films (Junction, In the Daylight, Stain)**

John Howard Swain

A veteran actor, director, producer and teacher, John has coached a myriad of clients ranging from first time actors to Emmy Award-winning performers, to Supreme Court Justices, to Fortune 500 executives. His acting credits include numerous roles off-Broadway as well as dozens of guest starring performances in episodic television including such classics as *Hill Street Blues* to current day *Law & Order: SVU,* plus he has starred in over 200 national commercials.

As a director he has staged over twenty plays including such hits as *That Championship Season, Veronica's Room, The Owl and the Pussycat,* and *The Hollow.* John has also directed five films including the multi-award-winning short film *A Younger Man.*

As a producer John has produced four independent films and is the driving force behind the theatrical production company 16 Coaches Long LLC. He is currently developing two plays to be produced in New York City.

For more information and updates please go to his website:
www.johnhowardswain.com